T0030495

Perpetual

Slavery

Ciarán

Finlayson

Perpetual Slavery is the fifth installment of the Critic's Essay Series published by Floating Opera Press. Comprising long-form essays, the series gives voice to critics who offer thought-provoking ways in which to subvert or replace normative modes of discussing culture and the world beyond.

Other essays in the series:
Queer Formalism: The Return, by William J. Simmons
Remember the Details, by Skye Arundhati Thomas
After Institutions, by Karen Archey
Notes on Evil, by Steven Warwick

Contents

Preface
7

Ralph Lemon
10

Cameron Rowland
49

Reparation under Duress
68

Preface

An earlier, shorter version of *Perpetual Slavery* was written in Berlin following the second wave of Black Lives Matter, after Jeremy Corbyn's second fall, and before Bernie Sanders's second rise. It hoped to contribute to some of the popular conversations at the time in strains of art theory, critical black studies, and the most recent iteration of the return to Marx—all discourses given political purchase by the international phenomena of millennial socialism and millennial black social movements. The present essay fills out some of the details of that earlier text and aims to show how art that exposes the historical intermingling of capital, forced bondage, and sociological insight can offer a nuanced understanding of slavery's afterlife.

This essay comprises extended readings of work by two living African American artists who approach the legacy of chattel slavery through inventive strains of post-conceptualism. First, Ralph Lemon's adaptation of 1960s task-dance, Fluxus event scores, and "meaningless work" to the physical capacities of Walter Carter—Lemon's elder collaborator and former sharecropper from Mississippi—aims to overcome the choreographic impasses of the 1990s. Lemon's work and his collaborations deal in a wry way with conceptual materials that include manual labor, agriculture, outsider art, the South, the ruins of the Reconstruction era, Roosevelt's New Deal, and the Civil Rights Movement, as well the body and dance, to probe cultural and political memory. Second, Cameron Rowland's combining of readymades with the contract art forms that emerged a half-century later casts a gimlet eye on the financial structures of the prison industry and the contemporary art world. It also gives Institutional Critique a new set of teeth through thematic engagement with the categories of intellectual labor, finance capital, mass incarceration, total administration, litigation, anti-aestheticism, and the foreclosure of large-scale political possibility after the Fall of Communism in 1989 or the global financial crisis of 2008.

Both artists interrogate a contradiction of capitalist modernity: chattel slavery has officially ended, but human emancipation has yet to arrive. Each artist

8

presses on this contradiction, treating its persistence as a determining element of the present. Their work is distinguished by the interesting and difficult claims on both the history of art and the history of capitalism sedimented within it. The readings that follow seek to draw out some of these claims, considering the meaning of the peculiar institution for the twentieth and twenty-first centuries as posed in two distinct bodies of work. Together, they are sides of a complex but not necessarily unitary whole.

Ralph Lemon

Freedom's Thicket

The "comic or idyllic" ending of the first volume of Karl Marx's *Capital* tells the story of a frustrated would-be capitalist in colonial Australia:[1]

> [Mr. Peel] took with him from England to the Swan River district of Western Australia means of subsistence and of production to the amount of £50,000. This Mr. Peel even had the foresight to bring besides, 3,000 persons of the working class, men, women, and children. Once he arrived at his destination, "Mr. Peel was left without a servant to make his bed or fetch him water from the river." Unhappy Mr. Peel, who provided for everything except the export of English relations of production to Swan River![2]

Marx relayed this in order to chastise a political economist for misunderstanding colonialism—the writer in question projected the conditions of the metropole across the world, forgetting that capital is first and foremost a social relation, not an objective one. This quiet escape has received less attention than the din that concludes the chapter on the historical law of capitalist accumulation, in which the death knell of private property clangs and "the integument is burst asunder" under its own weight and according to the system's own laws of motion.[3] Fredric Jameson praises this story of colonial workers stealing away en masse as "a mesmerizing image of liberation," one of few such pictures to populate the critiques of political economy.[4] A complementary image, even more enchanting, can be found in Marx's *Grundrisse*:

> The *Times* of November 1857 contains an utterly delightful cry of outrage on the part of a West-Indian plantation owner. This advocate analyses with great moral indignation—as a plea for the re-introduction of Negro slavery—how the Quashees (the free blacks of Jamaica) content themselves with producing only what is strictly necessary for their own consumption, and, alongside this "use value," regard loafing (indulgence and idleness) as the real luxury good; how they do not care a damn for the sugar and the fixed capital invested in the plantations, but rather

11

observe the planters' impending bankruptcy with an ironic grin of malicious pleasure, and even exploit their acquired Christianity as an embellishment for this mood of malicious glee and indolence. They have ceased to be slaves, but not in order to become wage laborers, but, instead, self-sustaining peasants working for their own consumption. As far as they are concerned, capital does not exist as capital, because autonomous wealth as such can exist only either on the basis of direct forced labor, slavery, or indirect forced labor, wage labor. Wealth confronts direct forced labor not as capital, but rather as relation of domination; thus, the relation of domination is the only thing which is reproduced on this basis, for which wealth itself has value only as gratification, not as wealth itself, and which can therefore never create general industriousness.[5]

Remarkable in the story, and in the glee with which Marx relates it, are the implications for the infernal question of historical transition—the integration of capital's violent prehistory into the ever-expanding circle of its self-determining system. Slavery had formally ended in the West Indies in 1834, but the twenty odd years that lapsed between emancipation and the publication of the slaver's news item was not enough time for capital to subvert abolition and transform the ex-slaves into dispossessed

workers, given to "general industriousness" and compelled by need to sell their labor-power on the market. Despite the fact that agricultural production in the colonies occurred at an industrial scale and for a world market, bourgeois social relations could not yet take hold.

This essay begins with the assumption that the seemingly narrow problem of transition posed in the passage from the *Grundrisse* opens onto questions that animate an active debate in contemporary art and politics: What is the bearing of the transatlantic slave trade on the present and how can it be overcome? What is the meaning of freedom in bourgeois society and to what extent are we living in a post-emancipation world? How should art, which is thought of as constitutively free, come to grips with the transformation of freedom into its opposite after abolition? How ought it express the decreasing viability of any meaningful, scalable escape from the fully administered world?

For cultural theorist Saidiya Hartman, we are not as far away from the matter as we might believe. In her 2006 memoir *Lose Your Mother*, she posed the "afterlife of slavery" as a definition of the present:

Slavery had established a measure of man and a ranking of life and worth that has yet to be undone. If slavery persists as an issue in the political life of black America, it is not because of an antiquarian

obsession with bygone days or the burden of a too-long memory, but because black lives are still imperiled and devalued by a racial calculus and a political arithmetic that were entrenched centuries ago. This is the afterlife of slavery—skewed life chances, limited access to health and education, premature death, incarceration, and impoverishment. I, too, am the afterlife of slavery.[6]

This assessment, which crystallized a set of enduring problems for the fields of critical theory and popular history, stems from her 1997 book *Scenes of Subjection*, in which she argued that the bestowal of liberal rights and freedoms upon slaves after the American Civil War delivered black Americans from the hell of chattel slavery only to then hurl them into the maw of state discipline and conscripted labor. The techniques of domination may have shifted in kind but not necessarily in intensity.

Since then, the relationships of capitalism to slavery, and slavery to the modern world have come under question in a new manner. Vincent Brown's survey of academic histories of slavery finds two types of politicization: those that narrate stories of "heroic subalterns" achieving micropolitical victories, small-scale escapes, in the grip of domination and those that outline "anatomies of doom" forming a "constitutive part of a tragic present."[7] In both cases, substantial movement in history appears

14

blocked. In such studies, where slavery is treated as deeper than the matter of physical domination and legal inequality between lord and bondsman, work conditions tend to fall away as a both a defining feature of slavery, and the category of labor fades into the background component of this history—or as a motor of history at all—and slave status assumes a largely metaphysical valence.

Lemon's and Rowland's works clear a way through this philosophical-historical thicket. The former, a New York–based choreographer-turned-conceptualist now seventy years old, did so in an series of videos, performances, photographs, and drawings made at the turn of the millennium with his centenarian collaborator Walter Carter. And the latter, a younger Philadelphia-born conceptual artist, through an influential 2016 exhibition of sculpture, works on paper, and institutional critique focused on prison labor and legal history at Artists Space titled *91020000*. This bureaucratic name is the customer number given to the venue by the New York State Department of Corrections, with which the nonprofit was legally required to register in order to purchase the prison-made commodities transformed by the exhibition into unassisted readymades.

At the level of form, both artists engage the legacy of modern art's self-negation. Using twentieth-century strategies of anti-art, they make works that bristle against being rendered as objects of aesthetic reflection and

sold as "artistic dry goods for the primary market" or boutique experiences in the black box.[8] Lemon's gravitation toward anti-dance and nondance forms on stage, his dissolving of medium-specific choreographic forms into gallery and print-based "paradance" artifacts, is essentially demanded by his objects of inquiry: disappearing black social dances, thwarted oral histories, the unmarked site of a lynching. In Rowland's case, the objects on view are, in the main, unremarkable commodities made by incarcerated workers. But the show's commitments to doing justice by these objects and their producers demand that it negate art at a deeper, more historically self-conscious level than anything achieved by recent avant-gardism. The prison goods cannot be bought, only borrowed, and then only on rather exploitative terms resembling installment plans forced upon the poor. In the tradition of first-generation conceptualism, Rowland subverts the market valorization of art and extends the gesture to include any additional profits that might be derived from the hyper-exploitation of penal labor that subsidizes the functioning of US government agencies and nonprofit organizations of all types. The contracts governing the circulation of these works are external to the sculptures and exhibition materials but they structure the whole operation, leaving their mark on the gallery checklist where the phrase "rental at cost" appears in place of a price.

Lemon's Black Period

In an on-stage video projection, Ralph Lemon walks across an empty road dressed in a white button-down shirt with a tie, thick black glasses, and cuffed jeans. He moves toward a lamppost, believed to be site of a lynching where the victim was strung up on a plum tree long since cut down and paved over. By turns, he falls against, sits beside, and lies next to the pole. Adjacent to the screen in this performance of *Come home Charley Patton* (2004) at the Brooklyn Academy of Music is a Nari Ward–designed sculptural set piece called *Attic Space*. Lemon stands inside, wearing a red shirt, and packs a retractable ladder into a wooden box mounted on the ceiling. He reads the following narrative:

> Elias did get into trouble one summer, visiting
> his Aunt Tempy up north, Jennie's sister in Duluth,
> creating rituals. Improvisational memorials
> throughout the state; places where something bad
> happened. He was so serious. "This is an act of
> sympathy." That's what he told the police officer,
> quoting James Baldwin. It was a really interesting
> idea, but all fake finally. He would suspend his body
> from specifically chosen vertical objects: hanging,
> falling in space not up or down, or, falling up and
> down from bridges, streetlights, trees. Once from

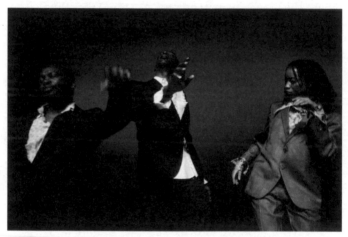

Ralph Lemon, *Come home Charley Patton*, 2004. Photo: Dan Merlo

an open fire hydrant. There wasn't much falling distance but he did get really, really wet. But not here. Here it was a yellow streetlight pole and a few memories. One was of all that water.

It began the day Jenny and Jeff got all dressed up, walked out of their house to the shed and rode their scrawny little horse off a cliff together. They fell, holding onto one another tightly, showing no excitement, the water booming below. Elias, who was a young boy then, was there watching from the top of the hill thinking it was all his fault. It wasn't. The horse was the first to hit the water. Then Jeff, then Jenny. "Damn, they ain't even scared. Oh shit! They weren't scared at all." Elias got older, was much older when he stood next to that yellow pole. He was arrested that summer in Duluth, on his birthday. Spent a few days in the county jail. When he got home he made this dance.[9]

A jaunty Piedmont Blues song by Rev. Gary David, "I Am the Light," plays as Lemon launches into a tortured buck dance, the plantation audible in its heavy stomps, visible in his high steps, serpentine torso, and low center of gravity, sagging beneath the weight of history. As he gets into the swing of it, two black men in civilian clothing and armed with a fire hose enter stage right, hitting him at close range with a high-pressure jet of water, knocking him over. The good and evil drama of

19

civil disobedience would overtake the scene except that the dancer seems indifferent to interruption. On the receiving end of a torrent, Lemon enters a cycle of slipping, falling, and dancing as water pools around him. The score, composed by Christian Marclay, shifts, and the devotional, optimistic reverend's fingerpicking gives way to rock drums and distorted guitars. Two dancers appear downstage, thrashing in isolation. The water jet ceases, and the two crowd controllers join the ensemble before they all collapse on the floor. Several minutes of punishing ecstatic dance ensue on a stage that's silent but for the grunts and thuds of the performers.[10] The movement slows to a trickle, a dancer half-heartedly splashes in a puddle, and a camera pans to a high-mounted screen where a line drawing of James Baldwin ventriloquizes an interview from the 1970s about the presence of Africa on the world stage: "Something is beginning to happen in the Western world, and everybody in one way or another is feeling this. What was presumed to be the center of the Earth has shifted and the definition of man has shifted with it. Does that make sense to you?"

These three scenes closing the video documentation of *Come home Charley Patton* circle back to the start of another series by Lemon, titled *The Geography Trilogy*. A decade-long inquiry into global dance cultures, the *Trilogy* began by bringing together West African and African American dancers for the *Geography* performance

in 1997. Six years later, it joined the Ivorian performers with dancers from South, Southeast, and East Asia for a study of Buddhist aesthetics titled *Tree*, and culminated in *Charley Patton*, the artist's non-Homeric return to the United States.

The trilogy inaugurated what Lemon semi-jokingly refers to as his "black period," dating from his sudden closure of Ralph Lemon Dance Company in 1995 following ten successful years of touring.[11] Still ongoing, this period coincides with his turn away from choreography for proscenium stage and toward research-intensive contemporary art presentations of works adapting performance to nontraditional venues. Having exhausted the tradition of postmodern dance, Lemon has set aside the title of choreographer and adopted the moniker "conceptualist." The post-stage works are defined by the distributive unity of what Lemon calls (in a riff on Gérard Genette) paradance: multimedia performance, video documentation, and accompanying process-books, as well as art-space presentations of its props, sets, scores, and other collaboratively made elements. The trilogy is guided by two concerns: first, the conservation of black social life sedimented in cultural practices, including those of non-black artists who are treated as black insofar as their work can be appropriated toward these ends, and, second, the navigation of a present whose meaning has been defined in a fundamental way by the triangular trade.

Ralph Lemon, *Untitled (James Baldwin)*, 2002. © Ralph Lemon

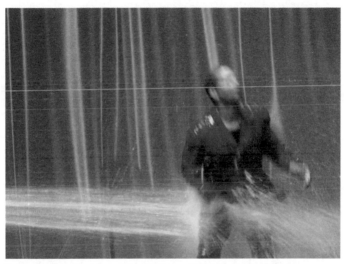

Ralph Lemon, *Come home Charley Patton*, 2004. Photo: Eric Stone

Lemon's collaboration with Carter defines this period. It commenced in November 2001, when he took his first trip south, accompanied by his daughter and videographer, Chelsea. Their research itinerary included retracing the route of the original freedom rides and site-scouting for Lemon's two-fold Dancing/Dying Tour. The first required visiting the closest living descendants of important Delta Blues musicians and improvising dances in their living rooms to recordings of their famous relations; the second meant enacting temporary "counter-memorials" at the anonymous sites of lynchings. In an ethnographic effort "to discover something authentic about the American South," Lemon sought out community elders and, in an act of "search and transmission," asked to see them dance. The first of these steps was the Buzzard Lope, taught to his research team by Hicks Walker, a centenarian living remotely on a Gullah-Geechee island off the coast of Georgia. The relationship was short-lived, as Walker passed away in 2002, not long after a second research visit. That same month, a visit to a Mississippi juke joint led Lemon to Walter and Edna Carter, an elderly couple living in the backwoods of Little Yazoo. At the time, Walter was an ex-sharecropper in his mid-nineties and Edna was his wife and caretaker. He became Lemon's collaborator and the two worked together until his death in 2002. Lemon also consecrated Carter as his muse. His aging body, wrote Lemon, "invoke[d]...the crescendo of dying."

Walter's Work

How Can You Stay in the House All Day and Not Go Anywhere, a multimedia performance first presented at Seattle's On the Boards theater in 2002, opens with a projection of Carter climbing into a rustic spacecraft and rolling on his back. On stage, Lemon narrates how on that day, inspired by Carter's Biblical interests, he read to him from the *Angelus Novus* fragment of Walter Benjamin's final major essay, "On the Concept of History." On screen, Walter, now in his backyard, smashes a ceramic rabbit with a brick. The video intercuts police brutality from the Civil Rights Movement with images of Bruce Nauman's *Wall/Floor Positions* (1968), as well as Lemon's reenactment of that work. After, the artist shows the "Fire Hose" and "Ecstasy" dances from *Charley Patton*, calling them "a glimpse of liberation."[12]

Lemon enlists Carter for "events" that include interpreting Fluxus-style scores, dressing in animal costumes and spacesuits, and reenacting scenes from the films of Andrei Tarkovsky and Jean-Luc Godard. Troubled by the idea that he might be exploiting Carter, Lemon reflected on these experiments years later:

Walter … walked down a slight hill from the two leaning sheds and began to dig a hole and found three buried 78 records unjacketed. He retrieved the records, dropped them off one at a time back up the

slight hill marking his path to a sitting tin tub. He
paused. He reached into the tin tub and retrieved
a set in place screwdriver and sardine can filled with
Crisco cooking grease. He took the screwdriver
and can filled with Crisco to a blue Egyptian vase
standing on a worktable with a brick resting in
its mouth. He smeared the Crisco onto the vase with
the screwdriver, greasing it up and down with a
vertical action. He repeated this action quite a few
times. Once finished he placed the sardine can
filled with Crisco and the screwdriver down onto
the table and took up a nearby green glass water
pitcher filled with water, carried it to the tin tub,
poured the water into the tin tub, and paused.
Still holding onto the empty green pitcher he walked
over to the vase with the brick and took the brick
from the mouth of the vase. Carrying the brick and
the pitcher he walked to the tin tub and pulled it
a few feet closer to a porcelain rabbit sitting nearby.
He moved to a stance directly next to the rabbit,
agilely nailing him with the brick: he smashed the
porcelain rabbit. He stood and paused. Holding
the empty pitcher, dangling the cabled brick in the
other hand, he dropped the brick. He picked up
the broken porcelain rabbit pieces scattered on the
ground and placed them in an empty pitcher. He
carried the pitcher full of broken porcelain rabbit

pieces up the hill to a freshly dug hole and buried the broken pieces. The event ended with Walter standing over the grave of the broken rabbit holding the shovel using it as a natural rest prop for a very long time. The event did not go as planned.[13]

In Lemon's descriptions, the success of the tasks he sets out for Carter correlates inversely to comprehensibility. These scores, for Lemon, make the "debris of life…sublime and unknown," an effect compounded by Carter's ailing body, which places them further from the familiar nonsense of contemporary performance. He becomes the "translator" through which Lemon makes sense of his own past practice, inspiring the "complete collapse" of the separation between a dancing body and the space of art.[14] Carter's ability to perform the tasks is limited by his memory, bodily capacity, and degree of interest. Lemon, as an inspired artist, wants to see his scores enacted but knows he must negotiate first with Edna and only then with Carter's own capacities. He calls this Carter's "co-opting" of the event,[15] but believes that a non-exploitative relationship might not be possible.[16] It is the impossibility that's interesting.

On the other hand, Carter has Ralph and Chelsea running his errands, driving him to grab a surreptitious beer and visit his daughter. Lemon describes Carter's faulty memory and failure to remain in character as

though they exert real force upon him: he's "battered" by the noncompliance but thrilled at the results of something beyond his control.[17] Carter's disobedience and forgetting prove that the dynamic is not, in the end, so unequal:

> For Walter there was always, at every moment, an exquisite position to action: digging, greasing, moving, breaking, forgetting. ... it is the work that is understood biologically, a long time ago, a direct work, not pampered, rehearsed, politicized, intellectualized, nor aestheticized—how fucking stunning. Walter was paid $100 a day for a few hours of his unquestioning time.[18]

The fair wage mediates and partially resolves the question of exploitation posed and held open by the work. At the same time, a certain romanticism about the South can be discerned in Lemon's statement about Carter's natural propensity for work, and an ideal of a less-alienated, agrarian labor embodied by the figure of the sharecropper. In a conversation with Saidiya Hartman at the Studio Museum in Harlem, Lemon describes the set of dirt roads where the Carters live in Mississippi as being uncontaminated by urban culture, less mediated by "capital and lots of other things."[19]

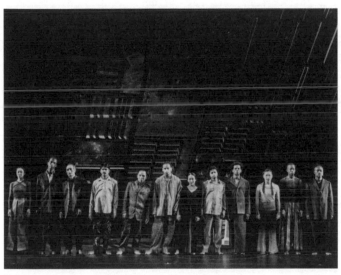

Ralph Lemon, *Tree*, 2000. Photo: T. Charles Erickson

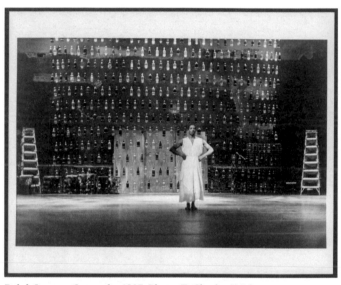

Ralph Lemon, *Geography*, 1997. Photo: T. Charles Erickson

In *How Can You Stay in the House*, Lemon talks of Carter as being born "fifty years or so shy of being a full-time slave."[20] But his actions, chance-operations of a sort, suggest resistance to work rather than the persistence of bondage. The most successful parts of the collaboration come from Carter's bucking orders. Two competing images of less- or un-alienated labor intersect with Carter: that of the artist—on both the romantic-aesthetic, naturalistic model (Milton, says Marx, wrote poetry as a spider spins its web)—and that of nineteenth-century African Americans on either side of emancipation. Prior to abolition, the slave's work songs and social dance loomed large in planter ideology as evidence of suitability for, and enjoyment of, their conditions;[21] afterward, the peonage of the ex-slaves contributed proof that Old South feudalism had not yet been brought under the iron laws of capitalist production.

Carter's native Yazoo-Mississippi Delta was the ground zero of Southern working class political resistance after the war, and, as sociologist Clyde Woods argues in *Development Arrested*, the "Blues Epistemology" that took hold around 1800 was forged in that struggle and championed opposition to work. Southern Enclosure, the mass eviction of tenant farmers and mechanization of their labor that followed the Reconstruction era and peaked with the New Deal, represented not a moment of "transition" to capitalist social relations but a

"movement from capital-scarce, labor-intensive plantation production to capital-intensive, labor-surplus neo-plantation production."[22] The planter oligarchs consolidated power in state legislatures, forming a federal lobby to secure a large labor pool in the face of widespread working-class resistance by variously canceling or seizing aid money given to sharecroppers by a Roosevelt administration that recognized their situation as nothing short of a national crisis. Without money or land, farm hands were forced back onto plantations; new vagrancy laws ensnared those who would not voluntarily return to the jobsite. The work resumed, without paternalistic illusions, under the surveillance of armed prison guards.

These relics of the plantation order should be considered part and parcel of a fully agrarian form of capitalism, rather than as archaisms of its properly industrial form.[23] The tenant farmers who struggled and organized from the 1890s through the 1950s made use of progressively rationalized techniques of industrial agriculture to produce for the world market. Their means of production had been transformed while the relations of production were frozen. Still, the appearance of the sharecropper as being outside of capitalist modernity is what makes the images of Carter compelling. Choreographer and performance theorist André Lepecki enthuses over the fact that Carter's remoteness from familiar artistic coordinates

allowed Lemon to move past the tropes of postmoderns to which his career had, until that moment, been unhappily indexed.[24] "What is amazing is that it took an angel of history, a former sharecropper as old as a century, and entirely outside the economies of discourses of art, to precipitate this other form of dance."[25] When the old idioms ceased to work as critical forms, there was a farmer dancer to revitalize the project.

There Is No Longer Any "Folk"

Where Woods found continuity in the social relations of production, recent historiography of the postbellum period has concerned itself with social ontology. Hartman is concerned with the way liberal freedoms bestowed on black Americans after the war in some ways extended and intensified the forms of domination they experienced. Thus:

> Lacking the certitude of a definitive partition between slavery and freedom, and in the absence of a consummate breach through which freedom might unambivalently announce itself, there is at best a transient and fleeting expression of possibility that cannot ensconce itself as a durable temporal marker. If periodization is a barrier imposed from above that

33

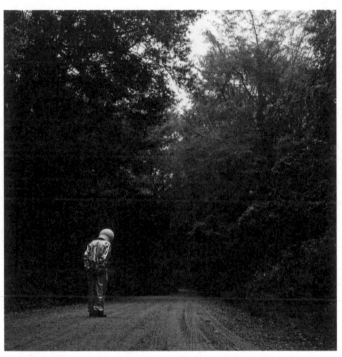

Ralph Lemon, *Untitled (Walter)*, 2009. © Ralph Lemon

obscures the involuntary servitude and legal subjection that followed in the wake of slavery, then attempts to assert absolutist distinctions between slavery and freedom are untenable.[26]

This observation was taken up by Frank B. Wilderson III, who joined it to Orlando Patterson's writing on "social death," a sociological ideal type adapted by Wilderson into an ontological position (in his parlance, a mode of existence so abject that even ontology is adequate, as a grammar, to explain it).[27] Where Patterson sought to integrate the African American experience of enslavement into a model explaining condition from antiquity to the present, Wilderson gives it a Fanonian twist: social death, for him, defines blackness itself because black people, regardless of class, are in irreconcilable antagonism with the rest of the world, and their experience of oppression is utterly incommensurable with that of any other group. On this approach, increasingly influential in art writing and contemporary critical theory, slavery is defined by parameters that are predominantly psychosocial, rather than material. The social death model shifts the study of slavery from the terra firma of political economy to the murkier fields of libidinal economy and political ontology, redefine slavery not as forced labor but as natal alienation, permanent subjection to general dishonor, and openness to gratuitous and unpredicated violence.

This sets the psychic profiles of people on either side of the master-slave relation (for which there is no outside) such that no real political unity can be forged to overcome its legacy.

However, at heart, the matter of being resolves into a problem of history. Those who follow the social death model to its horrifying end point uncover something ironically Hegelian in global social processes. Unifying a critically negative tradition in black studies, Wilderson writes that Hortense Spillers, Fanon, and Hartman all find that this gratuitous violence "continually repositions the Black as a void of historical movement," an insight that would not have been out of place in the *Lectures on the Philosophy of History*: Africa "is no historical part of the world; it has no movement or development to exhibit," and nor do its people.[28]

Thus, the social-death school claims insight into something more essential about the limits of freedom and history than can be admitted by the facts of emancipation. In anticipation of his future conversations with Hartman and Moten, we might read Lemon as linking this strain of black studies to the critique of historical progress extending from Marx to the Frankfurt School. In the selection of Benjamin that Lemon reads to Carter, progress appears as "one single catastrophe."[29] The German author's crying-out for histories of the oppressed did not abandon historical practice; instead,

36

it envisioned its movement in the manner of young Marx, for whom history advanced "on its bad side."[30] Adorno, who co-published that essay in 1942, took up its paradigm to redefine world spirit as a "permanent catastrophe"[31] in which political action is blocked by the totally administered world.[32]

Lemon reckons with the void of historical movement by means of Carter, who is both evidence that the grand evil of slavery is still in some sense present, and a resource for vital cultural forms that have eroded. For Lemon, Carter embodies a certain black popular spirit, the *Volksgeist* of a people "less mediated by capital" than others.[33] But the artist's concern for these souls operates in circumstances markedly different from W. E. B. Du Bois's at the turn of the century. While Du Bois and Hegel regarded popular spirits as the medium of historical movement, the meaning of national cultures and their power to explain developments in the present has waned in a world where the crisis has assumed transnational form.

Those atrocities of World War II confirm, for Adorno, that it is the individual, rather than the people, who is "the figure through which the universal, that is, the reproduction of the human world, is mediated."[34] This, in turn, transforms the social situation of art as well. "There is no longer any 'folk' whose songs and games could be taken up and sublimated by art; the opening up of markets and

the bourgeois process of rationalization have subordi-
nated all society to bourgeois categories," Adorno in-
tones.[35] Modern art, over and against folk culture, was
freed from its traditional cultural functions—religious
worship and veneration of nobility—and removed from
the sphere of immediate use, self-evident meaning, and
practical efficacy. As a part of society cut off from the
larger body, it is compelled by its commodity character
to progress in ways that mirror the market. Lemon is
ambivalent about the project of modern art and weary
of critiquing it, but the same is true of his relationship
to folk culture: he is attracted to its richness and har-
bors doubts about its present vitality. It exists for him as
ruins did for the Romantics.

From Memory, or Before

In the book *Come home Charley Patton* (2013), Lemon
details a visit to the home of Mose Tolliver, a self-taught
black painter from Montgomery, Alabama, widely
celebrated as "one of the leaders of the modern-day
Outsider Art movement."[36] Lemon's disenchantment
with the South plays out in the fragmented narrative.
He departs from the Civil Rights Museum, remarking
in a blow to both the institution and artist that Tolliver
is not represented on its walls and that his paintings

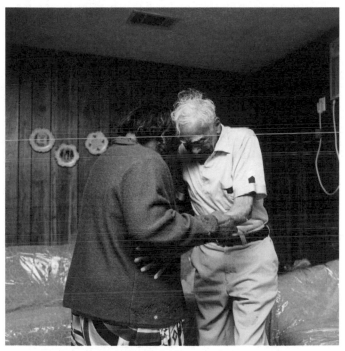

Ralph Lemon, *Untitled (Edna and Walter)*, 2009. © Ralph Lemon

were championed by Nancy Reagan. At the house, he is treated with suspicion by Mose T's relatives, who tell him to come back later. En route to his motel, a white cab driver takes him to see a local eccentric: a young man with dreadlocks wheeling around a shopping cart full of garbage. Lemon imagines the cabbie's racist fantasy, suspects he regards the young man as art, and fantasizes that he was one in the white mob who beat the freedom riders unconscious when they stopped in Montgomery.[37] Returning to Tolliver's, he finds the artist reluctant to discuss his work but happy to talk about his property. When asked why he paints, Tolliver replies:

> 'Cause I can't do nothin' else. Used to plant flowers and trees but my body can't do that work no more. Was really good at it. Anyway, so now I just paint. Did enjoy going to the White House, Mrs. Reagan invited me. Had a fine meal, ate whatever I wanted, a fine meal.[38]

Lemon says nothing about the artist treating painting as a day job, adding only that "the four hours go by quickly." He caps the episode with an unsourced italicized fragment transitioning to the Selma portion of the trip: "At least we had good music when the Negroes were demonstrating."[39]

Tolliver is a foil for Carter. While the painter adheres to his tradition, his expressionistic Americana lacks the

critical purchase of Carter's unvarnished actions. In fact, one might say that Carter, in Lemon's work, embodies Walter de Maria's famous treatise:

> Meaningless work is obviously the most important and significant art form today. The aesthetic feeling given by meaningless work cannot be described exactly because it varies with each individual doing the work. Meaningless work is honest. Meaningless work will be enjoyed and hated by intellectuals—though they should understand it. Meaningless work cannot be sold in art galleries or win prizes in museums—though old fashion records of meaningless work (most of all paintings) do partake in these indignities.[40]

Carter's attempts at accessing a blues folk tradition end up resembling the minimalist and post-Fluxus negations of dance that revolutionized the field in the 1960s (the same tradition Lemon's work in the 1980s sought to extend). Yet relentless self-doubt is the mood of these works and Lemon knows that the forms of social life that fascinate him and become the object of his work are most themselves when left alone. Lemon despairs, after injuring himself rehearsing the fire hose sequence in *Charley Patton*, lamenting that the music is "not (deadly) alive enough," which jeopardizes the whole piece.[41] Resigned

to the work's inadequacy compared to the actual culture of the South, he concludes that if Mississippi bluesman Othar Turner was having one of his backyard goat barbeque parties, he would "invite everyone to that and be done with it."[42]

Carter is a bearer of the dying blues tradition, and when Lemon has him dance steps from his adolescence, he moves "mostly his legs, sliding, without bending any limbs."[43] The movements appear less like the social dance of old than the anamnestic surfacing of antique social forms. In an exceptional piece of footage from 2005, shot in Yazoo City and shown as part of a performance-lecture presented with Hartman at Columbia University, Carter stands in a derelict theater on the city's main street, now open to the air for want of a roof. He shifts his weight metronomically from one foot to the other as rotten plywood strains beneath him, fully immersed in the effort. He dances "not the one-step, two-step or slow drag, but something even more forgotten, minimal. More like a preternatural shuffle from memory, or before." Lemon adds immediately after, "If truth be told it was probably a mindful improvisation on the spot of unbroken stage in silence for twenty minutes."[44]

The history of the South, the history of dance, and the history of art all converge in these performances. And these concerns inform Lemon's other endeavors as well. In *On Value*, a book he edited in collaboration with Triple

Canopy in 2016, there is a conversation between choreographer Sarah Michelson and curator Philip Bither, in which Michelson speaks with anxiety about dance being collected by the Museum of Modern Art and wonders whether it will result in a distortion of dance's history. All discussants acknowledge that it poses a problem, but none are not sure if there are any other adequate historicizing mechanisms for dance that are not art institutional, "apart from the *New York Times*."[45] Lemon's turn to Carter is in part a response to this development. In the same collection, he published an essay by Yvonne Rainer, "The Value of 'The Big Snooze' and Contingent Matters" (2015), detailing an unrealized performance in which Rainer would sleep beneath Henri Rousseau's *The Sleeping Gypsy* (1897), MoMA's most prized work of naïve art.[46] Four years earlier, he had commissioned a 2012 performance of *The Show Must Go On* (2002) by Jérôme Bel to take place in the museum's atrium. These works express and extend Lemon's choreographic practices reflecting on infrastructural transformations in dance. Rainer, Lemon, and Bel have each turned to nonprofessionals and amateurs, to outsiders, to probe the value of dance to art institutions and art history. One can reframe Lemon's collaborations with Carter within this extended practice and understand them as part of an older tradition of artists looking to the outside for what has escaped the administration of life and appears outside of history-as-the-history-of-capital.[47]

The meta-artistic writing Lemon reads over Carter's performance is a complement to the docufictional video work: it expresses anxiety about this relationship and adds a kind of ethical self-criticism that turns into Institutional Critique insofar as Lemon is the bearer of the institution's traditions. The performances and videos with Carter attempt to escape and refresh their own modernism, which sets them in motion and calls attention to the historical character of the "outside." This preternatural dancing bears the memory of catastrophe even as it is less alienated than all manner of self-conscious, professional art; Carter carries an ageless tradition in danger of being lost to old age.

Lemon registers this crisis in historical models and overcomes the separation by relentlessly putting the question of art's social function in relation to the theorizing of freedom, slavery, and history. He exhibits manifest anxiety over the keeping of tradition (loss of the old steps and the distortion of dance in the art museum), while, at the same time, he relentlessly turns against his own art-historical situation, pushing the work beyond the deadlocked confrontation between the ostensible void of historical movement on the one hand, and a purportedly vital sociality on the other. His work with and on Carter maintains critical negativity and political pessimism without leaving history for ontology or art for aesthetic immediacy. These achievements are

extended, in wholly distinct artistic language and more pointedly political forms, in the anti-aesthetic art of Cameron Rowland.

1 Fredric Jameson, *Representing Capital* (Brooklyn: Verso, 2011), 90.
2 Karl Marx, *Capital: A Critique of Political Economy*, vol. 1 (London: Penguin, in association with *New Left Review*, 1990 [1867]), 932–33.
3 Marx, *Capital*, 929.
4 Jameson, *Representing Capital*, 90.
5 Karl Marx, *Grundrisse: Foundations of the Critique of Political Economy (Rough Draft)* (London: Penguin, 1993 [1858/1939]), 325–26.
6 Saidiya V. Hartman, *Lose Your Mother: A Journey along the Atlantic Slave Trade Route* (New York: Farrar, Straus and Giroux, 2008), 10.
7 Vincent Brown, "Social Death and Political Life in the Study of Slavery," *The American Historical Review* 114, no. 5 (2009): 1236.
8 John Roberts, *Revolutionary Time and the Avant-Garde* (Brooklyn: Verso, 2015), 22.
9 Ralph Lemon, "Come home Charley Patton," in *Geography Trilogy* (DVD) (New York: Cross Performance, Inc., 2007).
10 A performer in the piece, Darrell Jones, attests: "Patton contained a section called 'Ecstasy.' It was three minutes long and highly rigorous. At first I felt that there wasn't a logic to what he was doing; he was just trying to see how far we could push our bodies. I felt angry, and I would direct that anger, not necessarily toward Ralph, but toward what he was pushing us to do. The pain got me through it. I stopped caring about Ralph's logic because performing the sequence felt like a personal goal. Going through that with somebody breeds a certain type of love and admiration but also resentment." Quoted in Adrienne Edwards and Thomas J. Lax, "Easter Eggs: A Narrative Chronology," in Thomas J. Lax, ed., *Ralph Lemon: Modern Dance* (New York: The Museum of Modern Art, 2016), 79.
11 James Hannaham, "Ralph Lemon," *BOMB Magazine*, no. 120 (July 1, 2012), http://bombmagazine.org/articles/ralph-lemon/.
12 *Ralph Lemon: How Can You Stay in the House All Day and Not Go Anywhere?*, video, 00:58 min., On the Boards TV, 2002, https://www.ontheboards.tv/performance/dance/theater/how-can-you-stay.
13 Ralph Lemon, "Keynote," *Making Time: Art Across Gallery, Screen and Stage Conference*, Arts Research Center, University of California,

Berkeley, April 20, 2012, https://www.youtube.com/watch?v=tLdMP-m4572Y.

14 Lemon, "Keynote."

15 Lemon, "Four Years Later," 272.

16 Lemon's interest in trickster figures such as Br'er Rabbit is apparent throughout his work. For more on Lemon himself as a trickster, see Claudia La Rocco's review of *Scaffold Room* (2014), "When Life Hands You Lemon," *Artforum*, October 3, 2014, https://www.artforum.com/performance/claudia-la-rocco-on-ralph-lemon-s-scaffold-room-48472.

17 Lemon, *Come home Charley Patton*, 272.

18 Lemon, "Four Years Later," 272.

19 "When the Stars Begin to Fall: Studio Lab: Saidiya Hartman, Ralph Lemon and Geo Wyeth," public program talk at The Studio Museum Harlem, May 16, 2014, YouTube, uploaded June 25, 2014, https://youtu.be/l_4bhRkwj_E.

20 Ralph Lemon, *How Can You Stay in the House All Day and Not Go Anywhere?*

21 See the "Formations of Terror and Enjoyment," in Saidiya V. Hartman, *Scenes of Subjection: Terror, Slavery, and Self-Making in Nineteenth-Century America* (New York: Oxford University Press, 1997), 15–112.

22 Clyde Woods, *Development Arrested: From the Plantation Era to the Katrina Crisis* (New York: Verso, 2007), 127.

23 Woods, *Development Arrested*, 6.

24 Katherine Profeta, "The Geography Trilogy: Take Your Body Apart and Put It Back Together," in Thomas J. Lax, ed., *Ralph Lemon*, 2016.

25 André Lepecki, "The Affective Physics of Encounter: Ralph Lemon and Walter Carter," in Thomas J. Lax, ed., *Ralph Lemon*, 116.

26 Hartman, *Scenes of Subjection*, 12–13.

27 Saidiya V. Hartman and Frank B. Wilderson III, "The Position of the Unthought," *Qui Parle* 13, no. 2 (Spring/Summer 2013): 183–201.

28 Frank B. Wilderson III, *Red, White & Black: And the Structure of U.S. Antagonisms* (Durham, NC: Duke University Press, 2002), 38.

29 Walter Benjamin, "On the Concept of History," in *Walter Benjamin: Selected Writings: Volume 4: 1938–1940* (Cambridge, MA: Harvard University Press, 2006), 392.

30 Karl Marx, "The Poverty of Philosophy: Answer to the Philosophy of Poverty by M. Proudhon," in *Karl Marx, Frederick Engels: Collected Works*, vol. 6 (New York: International Publishers, 1975 [1847]), 174.

31 Theodor W. Adorno, *History and Freedom: Lectures 1964–1965* (Cambridge, UK: Polity, 2002), 320.

32 Susan Buck-Morss, *The Origin of Negative Dialectics: Theodor W. Adorno, Walter Benjamin, and the Frankfurt Institute* (New York: Free Press, 1977), 171.

33 "When the Stars Begin to Fall," The Studio Museum Harlem.

34 Adorno, *History and Freedom*, 86.

35 Theodor W. Adorno, "On the Social Situation of Music," in *Essays on Music* (Berkeley: University of California Press, 2002 [1978]), 427–28.

36 Associated Press, "Mose Tolliver, Folk Painter of Outsider Art, Is Dead," *The New York Times*, November 3, 2006, https://www.nytimes.com/2006/11/03/obituaries/03tolliver.html.

37 Lemon, *Come home Charley Patton*, 54.

38 Lemon, *Come home Charley Patton*, 54.

39 Lemon, *Come home Charley Patton*. The quote is from Wilson Baker, the public safety director in Selma, denouncing the multiracial character of Freedom Summer after arresting 350 white protestors who "struck up an unmelodious version of 'We Shall Overcome.' Mr. Barker, his anger subsided, looked at his prisoners mournfully and said, 'this has ceased to be a Negro movement. It's became a misfit white movement.'" Roy Reed, "Selma Arrests 350, Mostly White Visitors, Near Mayor's Home," *The New York Times*, March 20, 1965, 13.

40 Walter de Maria, "Meaningless Work," in ed. Kristine Stiles and Peter Selz, *Theories and Documents of Contemporary Art: A Sourcebook of Artists' Writings* (Los Angeles: University of California Press, 1996), 526

41 Lemon, *Come home Charley Patton*, 190.

42 Lemon, *Come home Charley Patton*, 190.

43 Lemon, *Come home Charley Patton*, 132.

44 Ralph Lemon, "Ralph Lemon: 'Ceremonies Out of the Air,'" lecture at Columbia University School of the Arts, New York, February 27, 2015, YouTube, uploaded February 27, 2015, https://youtu.be/5Q6OPBCAl3Q.

45 Philip Bither, Ralph Lemon, and Sara Michelson, "He Gave Me Blues, I Gave Him Back Soul," in Triple Canopy and Ralph Lemon, eds., *On Value* (New York: Triple Canopy, 2016), 50. Lemon's work has been gathered together in a traditional artist monograph published by MoMA. It is the first in their Modern Dance series, professing a new, sustained institutional commitment to bringing dance into the museum on the terms of experimental art history.

46 Yvonne Rainer, "The Value of 'The Big Snooze' and Contingent Matter," in Triple Canopy and Ralph Lemon, eds., *On Value*, 151–58.

47 Katherine Jentelson, "Cracks in the Consensus: Outsider Artists and Art World Ruptures," in Thomas J. Lax, ed., *When the Stars Begin to Fall: Imagination and the American South* (New York: The Studio Museum in Harlem, 2014), 108.

Cameron Rowland

Making History

The handful of readymades comprising Cameron
Rowland's *91020000* unleashed a flurry of critical writ-
ing when they were first exhibited: *New York State Unified
Court System* (all works 2016), two rows of courthouse
benches; *Attica Series Desk*, a single cheaply made piece
of office furniture; *1st Defense NFPA 1977, 2011*, two
firefighter jackets; *National Ex-Slave Mutual Relief, Bounty
and Pension Association Badges*, two small pieces of recently
unearthed Civil War memorabilia; *Insurance*, three sets
of bars for lashing cargo aboard container ships, stretched
across the floor or dramatically wall-mounted in the
shape of an X; *Leveler (Extension) Rings for Manhole
Openings*, cast-aluminum roadwork tool piled atop and
beside a wooden pallet; *2015 NCIA Directory*, a bound
collection of datasets concerning American prison labor

published by the National Correctional Industries Association. And, lastly, two sets of documents: *Partnership*, a customer registration receipt formalizing Artists Space's connection with the New York State Department of Corrections and Community Supervision, Division of Industries; and *Disgorgement*, framed holdings in the insurance company Aetna, which historically issued policies to slave traders, presented alongside paperwork establishing a trust to "hold such shares until the effective date of any official action by any branch of the United States government to make financial reparations for slavery," at which point the stocks will be liquidated and paid out to as-yet-determined beneficiaries.

Each object makes a claim on history and brings the past into the present: *Insurance*, registered to Lloyds of London, binds global intermodal freight transport to the emergence of maritime insurance law with the triangular trade. *Leveler (Extension)*, ties contemporary prison labor to the era of the chain gang and the development of public infrastructure. The jackets in *1st Defense* were to be worn by prisoners conscripted to fight California wildfires, the "faithful labor" required by them of the state's Department of Corrections. These last two were manufactured by incarcerated workers; all three demonstrate the degree to which society is permeated by unfree work: from environmental protections to public works to planetary logistics. *Partnership* grounds the whole

Cameron Rowland, *91020000*, Artists Space, New York, Installation view

exhibition—it is the receipt allowing Rowland, via the gallery, to buy and exhibit these objects in the first place, as the purchase of prison-made goods is restricted to government agencies and nonprofit organizations.

Prisoners and Proletarians

Most sculptures in *91020000* are at one and the same time commodities like any other and, by virtue of their institutional setting, post-conceptual works indexed to the epochal rift of the 1960s. Of special interest in this regard is the relay between *Disgorgement* and *National Ex-Slave Mutual Relief, Bounty and Pension Association Badges*, concerning the movement for reparations. Both pieces forge links between what historian Robin D. G. Kelley would call the black radical imagination and art's own aspirations to freedom by rooting their social meaning in artistic strategies from the history of conceptual art—the former to the contract art that coalesced around curator Seth Siegelaub, the latter to Duchamp's readymades of the 1910s.[1] Here, the objects are presented without absurdist provocation and instead ask what it might mean for these straight-faced and unadorned objects to be works at all—precisely insofar as they are either socially useful or of basically historical (rather than aesthetic) interest.

The show was praised by Roberta Smith in the *New York Times* for offering "a history lesson and an aesthetic experience, intricately fused," and for doing so with critical insight that "accrues inexorably into an argument in the form of art for reparations."[2] A review by Alex Kitnick for *Artforum* perceived an argument "that the history of slavery (and the failure to make amends of it through reparations) continues to live on in our relations of property in general." Rowland's unaffected presentation of mundane objects (desks, benches) accompanied by extensive artist texts revealed the works' sites of production or historical origins, demonstrating that the history of slavery directly subtends the art world, too. This reveal is the basis for aesthetic appreciation of the work; it's the "capturing of the utterly delicate interplay between overarching systems and the specificities of a metal turnbuckle or a plastic laminate that sets Rowland's ensembles apart."[3] For both critics, then, Rowland departs from the anti aesthetic tradition represented by Duchamp and becomes a sort of neo-Dadaist, finding beauty in the readymades that had historically delivered a critique of beauty.

Art historian David Joselit attributed the show's success to the fact that it demonstrated continuity between nineteenth-century slavery and the twentieth-century prison industrial complex while achieving something new with the readymade form. These works detached

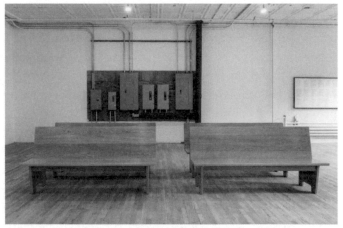

Cameron Rowland, *New York State Unified Court System*, 2016, Oak wood, distributed by Corcraft, 165 × 57.5 × 36 inches; Rental at cost

Courtrooms throughout New York State use benches built by prisoners in Green Haven Correctional Facility. The court reproduces itself materially through the labor of those it sentences.

Rental at cost: Artworks indicated as "Rental at cost" are not sold. Each of these artworks may be rented for 5 years for the total cost of the Corcraft products that constitute it.

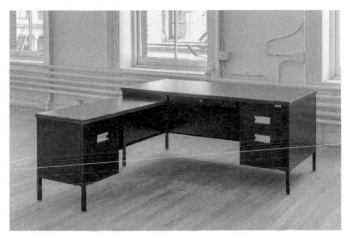

Cameron Rowland, *Attica Series Desk*, 2016, Steel, powder coating, laminated particleboard, distributed by Corcraft, 60 × 71.5 × 28.75 inches; Rental at cost

The Attica Series Desk is manufactured by prisoners in Attica Correctional Facility. Prisoners seized control of the D-Yard in Attica from September 9th to 13th 1971. Following the inmates' immediate demands for amnesty, the first in their list of practical proposals was to extend the enforcement of "the New York State minimum wage law to prison industries." Inmates working in New York State prisons are currently paid $0.10 to $1.14 an hour. Inmates in Attica produce furniture for government offices throughout the state. This component of government administration depends on inmate labor.

Rental at cost: Artworks indicated as "Rental at cost" are not sold. Each of these artworks may be rented for 5 years for the total cost of the Corcraft products that constitute it.

labor and objects "from their immediate context in an almost violent way," which "allowed for an even more complete extraction or separation ... from history."[4] Thus, "the objects are both evidence and not evidence of the objectification of human labor."[5] Legal theorist Cheryl Harris drew the opposite lesson: *91020000* shows the "racial genealogy of objects," she says, through the "seemingly fungible yet highly specific terms of their production, use, and circulation."[6] The artistic act consists then not in separating the work from history but "laying bare the origins of these objects to trace both the financial networks in which art commodities travel and the racially specific patterns of their production."[7]

Where Harris, Kitnick, and Joselit all see the labor behind the scene in *91020000*, Eric Golo Stone takes the argument even further, reading the work as demonstrating that the "art field" is based upon and "actively reproduces" a regime of property "rooted in the legacy of slavery."[8] This is evidenced by a national legal history that traces the passing of the Thirteenth Amendment through to re-enslavement by the convict leasing system in the South. Focusing primarily on Rowland's work, but specifically on the contracts drawn up by the artist to regulate its purchase, he argues:

Rather than render the groupings of objects disembodied from their laboring subjects, the artist's

56

legal agreements (the Aetna trust and Artists Space and Wattis registration and … a rental agreement) obligate the artist, and art-world relations, to recognize and disclose the continued histories of enslaved labor from which these objects derive.[9]

The artistic gesture in works such as *Attica Series* (2016) or *New York State Unified Court System* (2016) resides neither in an aesthetic experience of the work, though sensory perception is ineliminable, nor in our estimation of the racial makeup of the factory, though "racially-specific patterns" of production are essential. It operates conceptually at a higher level of abstraction; racial genealogies trace back to the hidden abode of production where freedom is, for Marx, *Vogelfreiheit*—an ironically double-coded term designating proletarians as both criminals and "free as a bird." Commodities, meanwhile are made under constraints by "free" workers who are fundamentally rightless, unattached, and unprotected.

Perpetual Slavery

The question of slavery, often conceived as a precursor to the properly capitalist exploitation of the nominally free worker, has bedeviled most efforts at schematic periodization. It appears at once as the original accumulation

necessary for the development of the world market, and as a dogged holdover from feudalism refusing to fade out with the rationalization of social relations promised by the bourgeois era. Free labor is foundational to Marx's theory of capitalist development. In order for the system to come into its own (for money to become capital in the simple act of circulation),

> the owner of money must find the free worker available on the commodity-market; and this worker must be free in the double-sense that as a free individual he can dispose of this labor-power as his own commodity and that, on the other hand, he has no other commodity for sale, i.e., he is rid of them, he is free of all the objects needed for the realization of his labor-power.[10]

In capitalist society—crucially, not one where labor time is *always and everywhere* exchanged for a wage, but where that social relation predominates—unfree labor that appears to exist outside capital's self-positing (as its prehistory) is brought into relation with nominally free labor via the concept of abstract labor. A heuristic "human labor in the abstract" is essential for the measurement of value, because it is principally indifferent to the concrete conditions under which any work is performed.

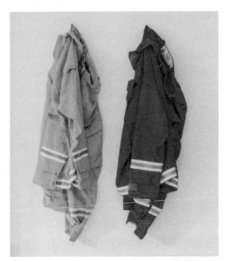

Cameron Rowland, *1st Defense NFPA 1977, 2011*, 2016, Nomex fire suit, distributed by CALPIA, 50 × 13 × 8 inches; Rental at cost

> "The Department of Corrections shall require of every able-bodied prisoner imprisoned in any state prison as many hours of faithful labor in each day and every day during his or her term of imprisonment as shall be prescribed by the rules and regulations of the Director of Corrections." – California Penal Code § 2700

CC35933 is the customer number assigned to the nonprofit organization California College of the Arts upon registering with the CALPIA, the market name for the California Department of Corrections and Rehabilitation, Prison Industry Authority.

Inmates working for CALPIA produce yellow Nomex fire suits for the state's non-inmate wildland firefighters.

Inmates working for CALPIA produce orange Nomex fire suits for the state's 4,300 inmate wildland firefighters.

Rental at cost: Artworks indicated as "Rental at cost" are not sold. Each of these artworks may be rented for 5 years for the total cost of the CALPIA products that constitute it.

Aside from being use values, commodities are, equally, socially validated human labor in the abstract: congealed, homogenous, and therefore quantitatively measurable. Marx's revelation of labor's abstract side gave insight into different but equivalent types of labor—simple and complex operations such as hand tailoring and industrial weaving, but also nominally free and unfree. It functions as the denominator between otherwise incommensurable types of productive human activity on a more ideal basis than money, which cannot escape its own materiality and commodity status and is therefore incapable of expressing value *as such* (it does so merely via price). Abstract labor is the social dimension of all the private independent labors; the equal value of the types of work has no bearing on formal equality between the workers. As Marx writes, the "discovery" of abstract labor "appears to those caught up in the relations of commodity production…to be just as ultimately valid as the fact that the scientific dissection of air into its component parts left the atmosphere unaltered in its physical configuration."[11]

Rowland's readymades point to the contemporaneity of slavery in a broader sense than that contained in a loophole to the Thirteenth Amendment. They testify to the participation of unfree labor in nominally free work without reifying themselves into artisanal art objects through which one might have unmediated aesthetic

Cameron Rowland, *National Ex-Slave Mutual Relief, Bounty and Pension Association Badges*, 2016, Pot metal, 1.25 × 1.25 inches and 1.25 × 1.25 inches

The National Ex-Slave Mutual Relief, Bounty and Pension Association was founded in 1898 by ex-slaves I. H. Dickerson and Callie House. It was one of the first organizations to advocate for ex-slave compensation. Members were provided with badges and certificates of membership. The certificate of membership read:

> "Having paid the membership fee of 50 cents to aid the movement in securing the passage of the Ex-Slave Bounty and Pension Bill, as introduced February 17th, to the 57th House of Representatives of The United States by the Hon. E. S. Blackburn of N. C. The holder of this Certificate agrees to pay ten cents per month to the local association to Aid the Sick and Bury The Dead. I hereby testify that I was born a slave in _____ and am entitled to all the benefits included in said Bill."

The badge on left was dug in Faison, North Carolina. The badge on the right was dug in Vicksburg, Virginia. Both were sold in 2015 by Civil War memorabilia dealers.

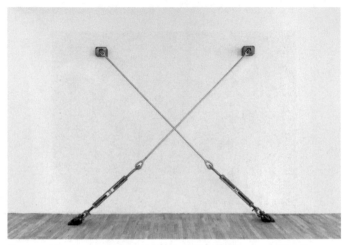

Cameron Rowland, *Insurance*, 2016, Container lashing bars, Lloyd's Register certificates, 102 × 96 × 11.5 or 149 × 18 × 4.5 inches

Lloyd's of London monopolized the marine insurance of the slave trade by the early 18th century. Lloyd's Register was established in 1760 as the first classification society in order to provide insurance underwriters information on the quality of vessels. The classification of the ship allows for a more accurate assessment of its risk. Lloyd's Register and other classification societies continue to survey and certify shipping vessels and their equipment. Lashing equipment physically secures goods to the deck of the ship, while its certification is established to insure the value of the goods regardless of their potential loss.

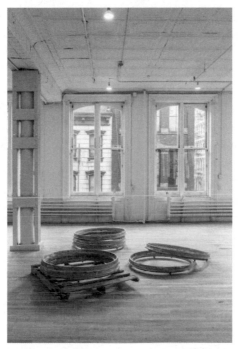

Cameron Rowland, *Leveler (Extension) Rings for Manhole Openings*, 2016,
Cast aluminum, pallet, distributed by Corcraft, 118 × 127 × 11 inches;
Rental at cost

Manhole leveler rings are cast by prisoners in Elmira Correctional Facility.
When roads are repaved, they are used to adjust the height of manhole
openings and maintain the smooth surface of the road. Work on public
roads, which was central to the transition from convict leasing to the chain
gang, continues within many prison labor programs. The road is a public
asset, instrumental to commercial development.

Rental at cost: Artworks indicated as "Rental at cost" are not sold. Each of
these artworks may be rented for 5 years for the total cost of the Corcraft
products that constitute it.

access to the concrete labor that produced them. At every moment they insist on their commodity status. While several relations of production might be operative at the level of individual capital—materials may pass through the hands of waged, indentured, conscripted, or enslaved workers at various points in the production process—they can only be brought into relation, analyzed in their abstract dimension, from the higher vantage of total social capital. In tying the methods and uses of contemporary prison labor to convict leasing and slavery via ubiquitous and unremarkable objects, Rowland presents us with ostensibly long-surpassed epochs of production and demonstrates their life in the present. Consideration of these objects means calling to mind the living labor freely given and involuntarily extracted that went into the lifeless commodities—the experience of them as works consists in grasping at once their concrete and abstract determinations. The admixture of different kinds of labor (and different periods of production) in each of the readymades suggests not only that the interdiction of reconstruction left emancipation incomplete, but has far-reaching consequences for our understanding of free work of any kind.

American historian Justin Leroy elaborates this work in his writing on racial capitalism. Like Hartman, he regards scholarship on nineteenth-century African American intellectual history and political thought as

overemphasizing the question of rights, citizenship, and formal equality, taking the rhetoric of emancipation at face value and becoming insensate to continuities between formal abolition and ideology. He grounds his claim that social conditions today are an amplification of chattel slavery, rather than its echo, in a testimony by James McCune Smith, a black abolitionist from New York City, who, in 1865, wrote:

> There is no political, religious, or philanthropic agency at work that can encompass the entire abolition of slavery. In slave society, labor lies prostrate and capital dictates its own terms, which are perpetual subjugation, in other words, perpetual slavery. Far from this war diminishing the wish or power of capital to own labor, it will increase both.[12]

Like Smith's anticipation of what Du Bois would call the "dictatorship of property,"[13] the mute objects gathered in *91020000* bear witness to both aspects of abolition: the epochal liberation of human chattel from direct exploitation and the world-scale emancipation of industrial capital.

1 The creation of the readymade has been tied biographically to
 Duchamp's aspirational aristocratic desire to steer clear of anything
 resembling hard labor. In Maurizio Lazzarato's *Marcel Duchamp
 and the Refusal of Work* (Los Angeles: Semiotext(e), 2014), he reads
 Duchamp's life as refusing both artistic and waged work, and the
 readymade as the premier form of "lazy action," because it requires
 no artistic virtuosity or manual labor to transform the commodity
 into an artwork. Similarly, art historian and curator Helen Molesworth
 has identified Duchamp's early readymades with work avoidance
 and maintenance labor, after Mierle Laderman Ukeles, for the way in
 which they put work and leisure into "extreme proximity," adding
 a dimension of play to objects otherwise wholly beholden to their "use."
 Duchamp attempts to free works even from their "use" as art beyond
 art's purported uselessness. Both Lazzarato and Molesworth read
 him in the tradition of Paul Lafargue, Marx's black son-in-law who,
 in 1883, published a satirical pamphlet called "The Right to Be
 Lazy" that became a touchstone for anti-work polemics. As much as
 Rowland's works "reveal" an open secret about the conditions of
 their production, in their openly Duchampian form they speak to the
 rejection of work and the negation of art.
2 Roberta Smith, "In Cameron Rowland's '91020000,' Disquieting
 Sculptures," *The New York Times*, January 28, 2016, https://www.
 nytimes.com/2016/01/29/arts/design/in-cameron-rowlands-
 91020000-disquieting-sculptures.html.
3 Alex Kitnick, "Openings: Cameron Rowland," *Artforum* (March 2016), 265.
4 Huey Copeland, Dipesh Chakrabarty, David Joselit, Kara Keeling,
 Kobena Mercer, Michelle Kuo, and Emily Roysdon, "Collective
 Consciousness: A Roundtable," *Artforum* (Summer 2016), https://
 www.artforum.com/print/201606/dipesh-chakrabarty-david-
 joselit-kara-keeling-kobena-mercer-michelle-kuo-and-emily-roys-
 don-moderated-by-huey-copeland-60095."
5 Copeland et al., Collective Consciousness."
6 Cheryl I. Harris, "The Afterlife of Slavery: Markets, Property
 and Race," lecture at Artists Space, Books & Talks, New York,
 January 18, 2016.
7 Harris, "The Afterlife of Slavery."
8 Eric Golo Stone, "Legal Implications: The Everyday Life of Marcel
 Duchamp's Readymades," *Art Journal* 57, no. 4 (1998): 50.
9 Stone, "Legal Implications," 102.
10 Marx, *Capital: A Critique of Political Economy*, vol. 1 (London: Penguin,
 in association with New Left Review, 1990 [1867]), 272–73.

11 Marx, *Capital*, 167.
12 Justin Leroy, "Race, Finance, and the Afterlife of Slavery," lecture at Whitney Museum of Art, New York, March 29, 2017, YouTube, uploaded May 1, 2017, https://youtu.be/CHezrnRe9K0. On a similar note, from the right wing of the labor movement, here is the perverse anti-abolitionist Marxist Hermann Kriege, writing eleven years earlier: "That we see in the slavery question a property question which cannot be settled by itself alone. That we should declare ourselves in favor of the abolitionist movement if it were our intention to throw the Republic into a state of anarchy, to extend the competition of 'free working men' beyond all measure, and to depress labor itself to the last extremity. That we could not improve the lot of our 'black brothers' by abolition under the conditions prevailing in modern society, but make infinitely worse the lot of our 'white brothers.' That we believe in the peaceable development of society in the United States and do not therefore here at least see our only hope in conditions of the extremist degradation that we feel constrained therefore to oppose Abolition with all our might, despite all the importunities of sentimental philistines and despite all the poetical effusions of liberty-intoxicated ladies." W. E. B. Du Bois, *Black Reconstruction in America: 1860–1880* (New York: The Free Press, 1998 [1935]), 23.
13 Du Bois, *Black Reconstruction*, 583.

Reparation under Duress

The legal battle for reparations, which lays claim on postbellum riches, has long had a utopian dimension in which history could be set right or started anew. Theorist Denise Ferreira Da Silva has made the movement for it central in her ethical, epistemological, and poetical critique of historical materialism. For her, the moral imperative to end the world and our ways of knowing it (through history and science) means "to reclaim, to demand the restoration of the total value the colonial architectures have enabled capital to expropriate from native lands and enslaved black (and African) labor."[1] Similarly, Wilderson argues:

> Reparations suggests a conceptually coherent loss. The loss of land, the loss of labor power, etc.

In other words, there has to be some form of articulation between the party that has lost and the party that has gained for reparations to make sense. No such articulation exists between Blacks and the world. This is, ironically, precisely why I support the Reparations Movement; but my emphasis, my energies, my points of attention are on the word "Movement" and not on the word "Reparation." I support the movement because I know it is a movement toward the end of the world; a movement toward a catastrophe in epistemological coherence and institutional integrity—I support the movement aspect of it because I know that repair is impossible; and any struggle that can act as a stick up artist to the world, demanding all that it cannot give (which is everything), is a movement toward something so blindingly new that it cannot be imagined. This is the only thing that will save us.[2]

For both, black politics stands in opposition to history; Rowland's show meditates on these ideas of stasis and progress by figuring the history of the movement.

The two works embodying Rowland's "art for reparations" mark the earliest and the most recent attempts to claim these cataclysmic sums. The first, *National Ex-Slave Mutual Relief, Bounty and Pension Association Badges*

(2016), consists of two humble pot-metal badges in the shape of a moon and star made during the Reconstruction era for members of the black mutual aid society founded to fight for federal reparations. In response to a fraudulent effort by William R. Vaughn, a white Congressman from Alabama, to introduce a bill authorizing pensions for freedmen, Rev. Isaiah H. Dickerson and Mrs. Callie D. House fundraised in support of North Carolina Congressman E. S. Blackburn's "Ex-Slave Bounty and Pension Bill" in the late 1890s.

Disgorgement, the second of these, draws on current efforts to secure reparations through lawsuits against insurance companies that have profited from investments in slave policies. The piece consists of a "reparations purpose trust" and ninety shares in Aetna, Inc., one such business that grew its wealth in large part from policies issued to nineteenth-century slavers. As a legal document, *Disgorgement* is connected to Congressional Bill H.R. 40. First introduced by Michigan Congressman John Conyers in 1989 and still brought before Congress each year, it would establish a "Commission to Study Reparations Proposals for African-Americans." Upon the passage of this or any other such legal initiative, the stock will be sold and the money given to a federal agency to oversee its redistribution. Between these two works stands a whole multifaceted history of social struggle.

During the American Civil War, following General Sherman's executive order, reparations stood for the dream of something like unalienated labor, where freedmen could use the new land for direct consumption. Afterward, it embodied a demand for pensions for thousands of elderly and infirmed freedmen, who represented a biopolitical crisis for the Union once they ceased to be the individual dependents of slavers. House and Dickerson's organization sought to support black workers after retirement on the basis that, as a new section of the citizenry, elderly black workers were owed for a lifetime of uncompensated labor. In the twentieth century, the cause was taken up by Black Communists such as Harry Haywood, whose work in the Third International made the right to black self-determination and entitlement to fertile land in the southeast of the United States a component of Soviet foreign policy under Stalin. In the wake of African and Caribbean decolonization, the demand was taken up by various Black Nationalisms under the logic of national partition. The Detroit-based Republic of New Afrika envisioned payments in land and seed money for a new country modeled on the Tanzanian socialism of Julius Nyerere. Jesse Jackson envisioned a "Freedom Budget" to fund community programs; "Queen Mother" Audley Moore imagined the money would develop black industry and finance repatriation for all who wanted it.[3] In contrast to these grand, convulsive

visions, the movements referenced by Rowland's works are modest and yielded only two bills that never cleared the floor—one providing pensions for disabled former slaves deprived of even undignified "retirement" on the plantation; the other hoped only to establish a committee to inquire as to how reparations might one day be made.

The member badges are staid fragments of hope for a future where things might have been different, in which abolition democracy carried the day. No conceptual device turns the memorabilia objects of special aesthetic experience. It's their proximity to the current political discussion that gives them interest and the capacity to express the deficiencies of the present. *Disgorgement*, on the other hand, works by superseding much in the art world that goes by the name Institutional Critique. Unlike, for instance, Hans Haacke's exposé of New York slumlords tied to the Guggenheim in *Shapolsky, et al. Manhattan Real Estate Holdings, a Real-Time Social System* (1971), Rowland's framed documents suppress the catharsis of the scandal. The work reveals institutional complicity with evil but goes further, forcing its hand in the most unspectacular ways, redirecting the art world's money back into the coffers of the finance and insurance systems at the heart of so-called primitive accumulation in America. Being a financial document, it not only incites response from viewers, but also has the capacity to enforce its contents. In this, it has an

advantage over forms of social practice where engagement with a public is limited to soliciting the voluntary participation of the audience. The work realizes itself in the world according to its own formal, legal mechanisms; going into effect when history presents the conditions for its realization.

The work reflects on the institutional conditions of contract art and on the historical form of the contract itself, which is, according to Da Silva, the point on which the historical materialist tradition falters. Because Marxists emphasize contractuality in their theories of exploitation, they necessarily de-emphasize slavery, a category of labor governed not by contract but title.[4] Slave insurance then, which emerged at the inception of life insurance and maritime shipping insurance, is a point where contract and title converge (for calculating and securing the value of the slave's labor-power over time) and bridges the Marxist and post-Marxist understandings of the history of slavery and its political implications today.[5]

In 2015, the Movement for Black Lives, a coalition of more than fifty groups representing the interests of black communities across the United States, built on renewed enthusiasm for reparations (kick-started by a Ta-Nehisi Coates's widely read article "The Case for Reparations" in the *Atlantic*) made the demand for reparations a plank in the struggle against police murder and anti-black violence. Such approaches came under fire

from certain parts of the left. Political scientist Adolph Reed, for one, dismissed the revival of the reparations movement as nothing more than the "psychobabble" of the black bourgeoisie and the media class whose ear it has, drowning out efforts to unify the working class in the aftermath of the 2008 financial crisis.[6] As neoliberals in radical garb, the argument goes, reparations activists capitulate to the given order and its idea of justice that consists in "restoring to people what they would have had if the labor market or the housing market or the loan market hadn't taken it away from them."[7] In this view, Da Silva's and Wilderson's revolutionist demands for "the restoration of the total value," of the colonial system—and thereby the end of the world[8]—remains in thrall to market logics that it cannot overcome.

The works in *91020000* bring us somewhere other than black eschatology, but retain its "punk negativity."[9] They neither polemicize for revolution nor adjudicate the pragmatics of this or that political campaign. They use the idea of the slave to work through history, circumventing the displacement of political thinking into metaphysics and ethics. Because the work constantly displaces itself, even in relation to its own historical concept, it avoids both the re-reification of readymades into "aesthetic art" and the evasion of politics that occurs when manifold social movements are subsumed under a universal history of anti-blackness.

There is wry humor in *Disgorgement*'s image of repair, as though any congressional bill might clear the charnel house. The plainly framed copy paper contract adopts the "aesthetics of administration" that characterized the first generation of New York conceptual artists.[10] As an image of freedom, it is mimesis of the administered world. If, as Reed proposes, the movement for reparations represents black politics' "absolute submission to the primacy of the market," *Disgorgement* responds with Adorno's insight that "only by immersing its autonomy in society's *imagerie* can art surmount the heteronomous market."[11] The work stoically participates from the delimited position of contemporary art, dramatizing its uselessness and pushing its boundaries to the extreme. No salvific violence can rush to its aid. It exhibits commitment without giving consolation.

Making Ends Meet

"The classless society, which will satisfy needs and abolish the irrationality in which production for profit is entangled, will likewise abolish the practical spirit that still asserts itself in the aimlessness of the bourgeois notion of *l'art pour l'art*. ... To be useless then will no longer be shameful."
—Adorno and Horkheimer, *Toward a New Manifesto*

91020000, like Lemon's Southern works, is suffused with muted references to political organization and draws negatively upon histories of struggle and defeat since the American Civil War. Both sets of work, by focusing on limit-cases between bondage and freedom, reinsert the question of labor and the figure of the worker into the discourse on slavery's afterlife (it should not be forgotten that the 1971 rebellion at Attica began with a strike in the prison's metal shop). It's through such figures that they uncover new and vivid means for representing the present in view of these intractable problems. Rowland highlights forms of exploitation and domination tied to postbellum histories that are, at the same time, ubiquitous in global commodity production by means of unassisted readymades and purposely impotent trusts. Through this, they bring slavery and *Vogelfreiheit* together in the prison—reminding us, in the words of Werner Bonefeld, that "class struggle is the everyday experience of the bourgeois freedom to make ends meet." Together with Walter Carter, Lemon reenchants meaningless work—labor-intensive Fluxian action severed from productivity—which becomes a kind of leisure for the sharecropper. (When Lemon offers to show Carter the finished product, he declines, saying, "I'm having a good time, I like the work.") For both artists, art's uselessness becomes a point through which it articulates social insight, a means for considering the

ex-slave, the prison slave, and the wage slave as they each shape the meaning of the past. Forgoing both consciousness-raising and social practice, they engage with history though crystalline manifestations of present impasses, calling attention to their own enmeshment in the administered worlds of art, finance, and even direct domination, without illusion or resignation. The works succeed, not despite, but by means of the separation from the world that they continually reenact. Look carefully enough and one might catch sight of the Quashees' ironic grin.

1 Denise Ferreira Da Silva, "Toward a Black Feminist Poethics: The Quest(ion) of Blackness toward the End of the World," *The Black Scholar* 44, no. 2 (2014): 82.
2 Percy Howard, "Frank B. Wilderson, 'Wallowing in the Contradictions'," Part 1, *A Necessary Angel*, September 7, 2002, https://percy3.wordpress.com/2002/07/09/frank-b-wilderson-%E2%80%9Cwallowing-in-the-contradictions%E2%80%9D-part-1/.
3 Robin D. G. Kelley, *Freedom Dreams: The Black Radical Imagination* (Boston: Beacon Press, 2002), 120–34.
4 Denise Ferreira Da Silva, "Reading the Dead," lecture at The Showroom, London, April 25, 2017, https://www.theshowroom.org/library/object-positions-public-lecture-3-reading-the-dead-denise-ferreira-da-silva-in-conversation-with-shela-sheikh.
5 Da Silva, "Toward a Black Feminist Poethics," 83–85.
6 Adolph Reed Jr., "The Case Against Reparations," Nonsite.org, November 2, 2016, https://nonsite.org/editorial/the-case-against-reparations. Originally published as "On Reparations," in *The Progressive* (December 2000).
7 Walter Benn Michaels and Kenneth Warren, "Reparations and Other Right-Wing Fantasies," Nonsite.org, November 2, 2016, https://nonsite.org/editorial/reparations-and-other-right-wing-fantasies.
8 Da Silva, "Toward a Black Feminist Poethics," 82.

9 Hannah Black and Paige K. Bradley, "Interviews: Hannah Black,"
 Artforum, June 10, 2015, https://www.artforum.com/interviews/
 hannah-black-discusses-her-solo-exhibition-in-london-at-arcadia-
 missa-55300.
10 Benjamin H. D. Buchloh, "Conceptual Art 1962–969: From the
 Aesthetic of Administration to the Critique of Institutions,"
 October 55 (Winter 1990): 105.
11 Theodor W. Adorno, *Aesthetic Theory* (London: Continuum, 2012
 [1970]), 21.

Acknowledgments

This text was originally written for the online journal *PARSE—Platform for Artistic Research Sweden* (2018) and has been revised and edited for clarity. Thanks are due to Marina Vishmidt and Dave Beech for commissioning the original, and Emma Fajgenbaum and Aaron Bogart for their generosity and insight into this revision.

I remain grateful to Asma Abbas, Hannah Black, Isaac Brosilow, Christina Chalmers, Miri Davidson, Elizabeth Davis, Bill Dietz, Lorel Easterbooks, Colin Eubank, Freya Field-Donovan, Ari Fogelson, Kylie Gilchrist, Larne Abse Gogarty, Jack Gross, Steve Hager, Louis Hartnoll, Brendan Harvey, Tobi Haslett, Isabella Lee, Tong Mao, Sara Mugridge, Greg Nissan, Rachel O'Reilly, Peter Osborne, Theresa Paquette, Lucy Peterson, Gabriel Salgado, Stephanie Schwartz, Salma Shamel, Oliver Silverman, William Spendlove, Kerstin Stakemeier, and Milo Ward for providing opportunities to present and receive feedback on earlier version of this material, or for their insight on the project and encouragement in its republication.

Thanks, most importantly, to my parents, for their unending love and support.

Colophon

Series editor:
Aaron Bogart

Editor:
Emma Fajgenbaum

Copyediting:
Louisa Elderton

Proofreading:
Jude Macannuco

Graphic design:
Daniela Burger

Typesetting:
Vreni Knödler

Typeface:
Kelvin Avec Clair

Printing:
druckhaus köthen

Paper:
F-color Karton Feinkorn,
Munken Print White

Published by
Floating Opera Press
Hasenheide 9
10967 Berlin
www.floatingoperapress.com

ISBN 978-3-9823894-4-8

Printed in Germany